The

REVERSE
COLORING BOOK

KENDRA NORTON

Workman Publishing
New York

ISBN 978-1-5235-1527-1

Design by Becky Terhune
Cover art by Kendra Norton

Workman books are available at special discounts when purchased in bulk for premiums and sales promotions as well as for fundraising or educational use. Special editions or book excerpts can also be created to specification. For details, contact the Special Sales Director at specialmarkets@workman.com.

Workman Publishing Co., Inc.
225 Varick Street
New York, NY 10014-4381

workman.com

WORKMAN is a registered trademark of Workman Publishing Co., Inc.

Printed in China on FSC®-certified paper.
First printing June 2021

10 9 8 7 6 5 4 3 2 1

"You can't use up creativity.
The more you use, the more you have."
—Maya Angelou

Hello friends,

Welcome to my debut art book!

I created this book after realizing that I wanted to improve my drawing skills, and also to combine those skills with painting—one of my true loves. I landed on the idea of drawing on partially completed paintings because it gave me a place to start from. (The blank page can be intimidating!) The more I shared my creations, the more my friends and loved ones told me they wanted to try it, too. It made me realize that everyone can use a prompt or a boost sometimes.

These watercolors are meant to inspire your inner artist to let loose. You can follow the shapes, outline them, draw inside them or around them, or change them with your pen and your ideas.

I'd be thrilled if you'd take a photo of your pages as you create them and post on Instagram with the hashtag #thereversecoloringbook. You'll get to see what I've created as well as many other reverse coloring masterpieces—and you'll become part of an inspiring community that loves celebrating connection through creativity!

Stay well, and I hope to see you soon!

Kendra Norton

P.S. Stay connected with me on Instagram @kendranortonart to see what I am up to!

REVERSE COLORING IDEAS

Not sure where to start? Try some of these ideas and see where they take you!

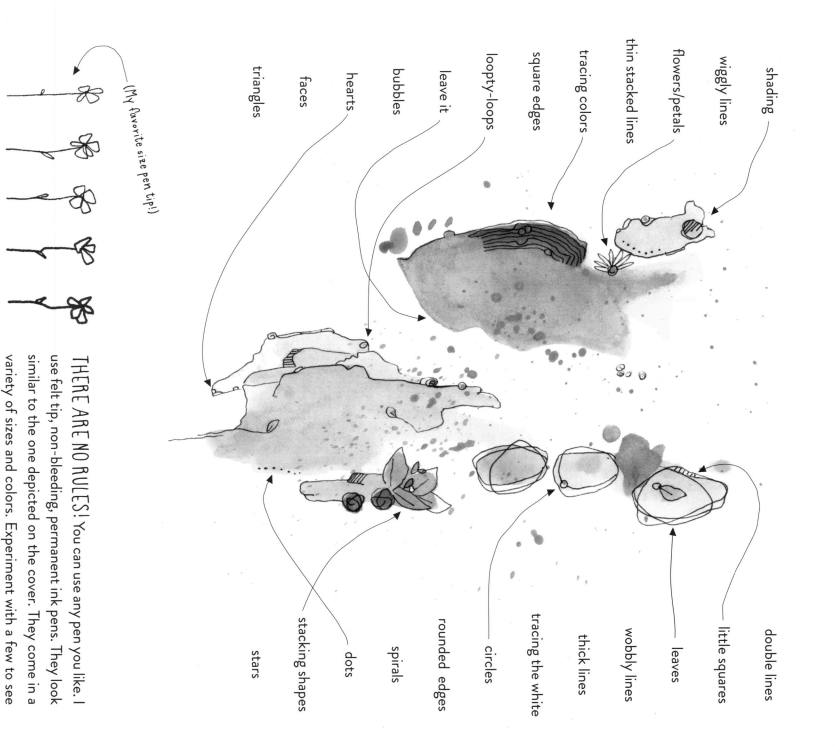

shading
wiggly lines
flowers/petals
thin stacked lines
tracing colors
square edges
loopty-loops
leave it
bubbles
hearts
faces
triangles

double lines
little squares
leaves
wobbly lines
thick lines
tracing the white
circles
rounded edges
spirals
dots
stacking shapes
stars

(My favorite size pen tip!)

005 MM
01 MM
03 MM
05 MM
08 MM

THERE ARE NO RULES! You can use any pen you like. I use felt tip, non-bleeding, permanent ink pens. They look similar to the one depicted on the cover. They come in a variety of sizes and colors. Experiment with a few to see what you love best!

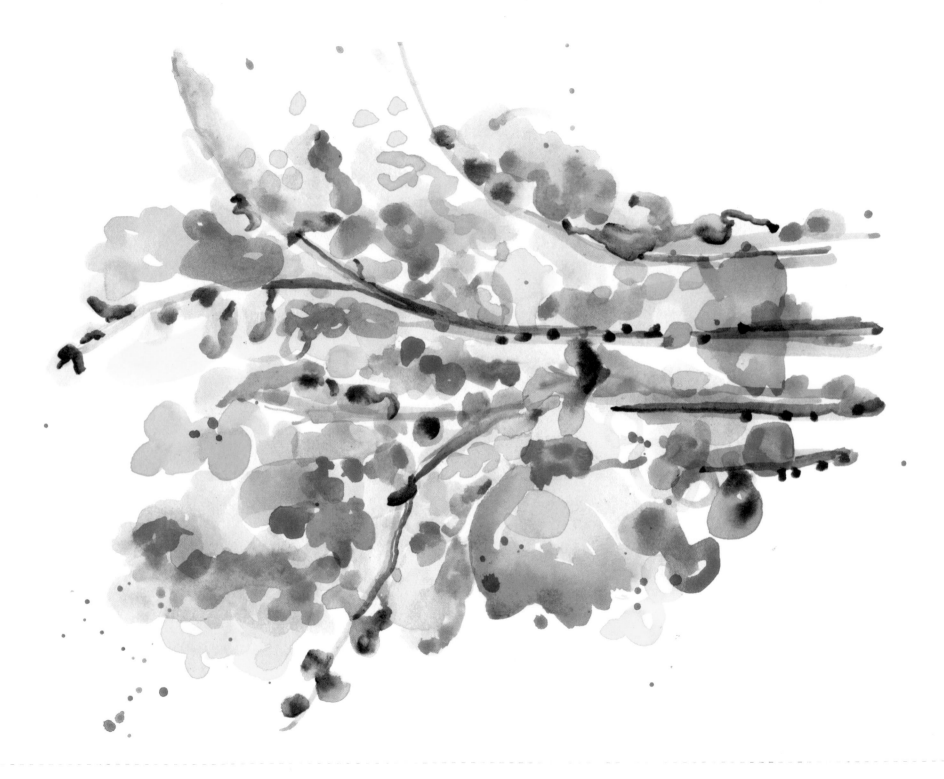

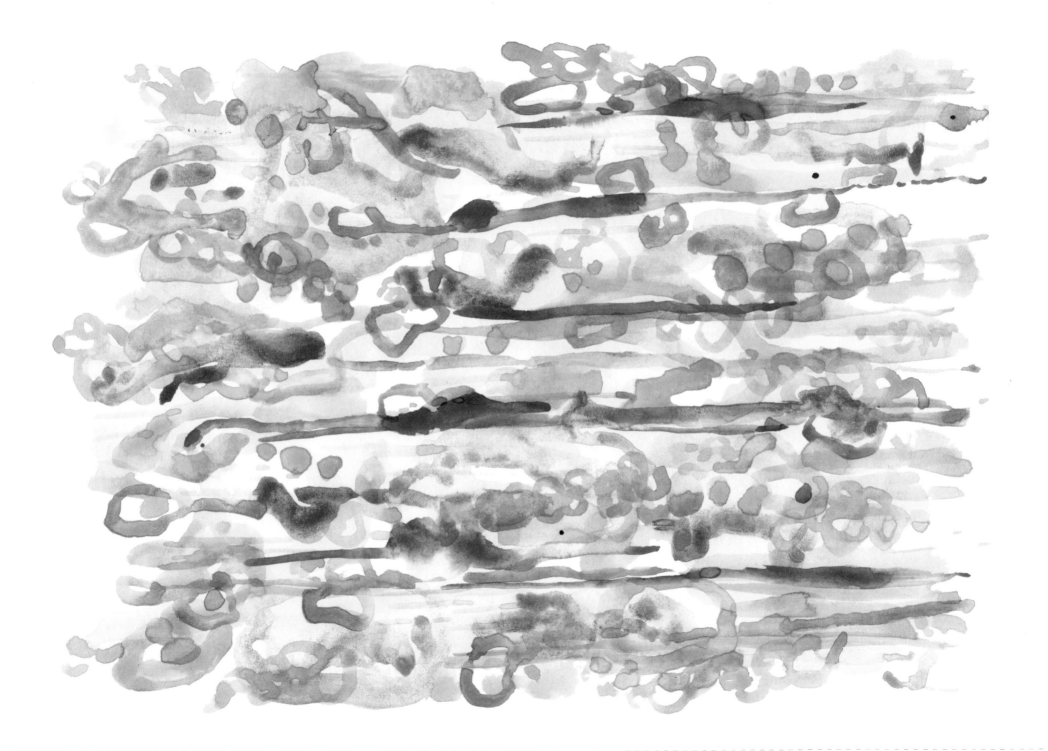

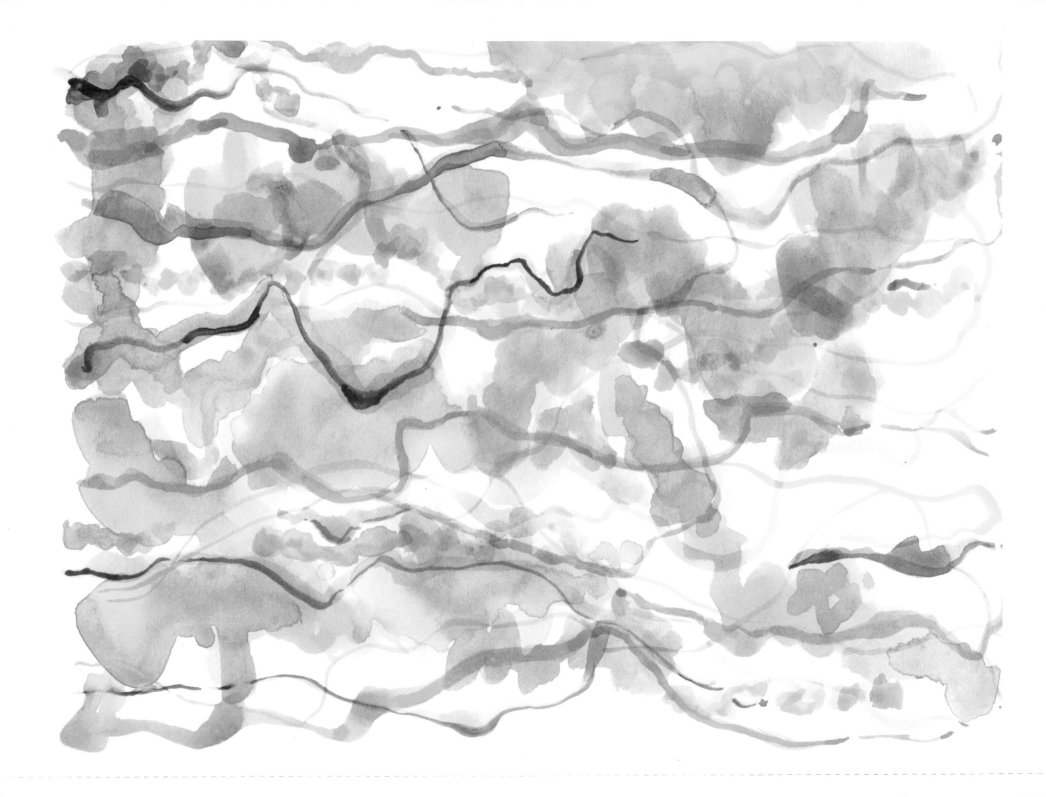

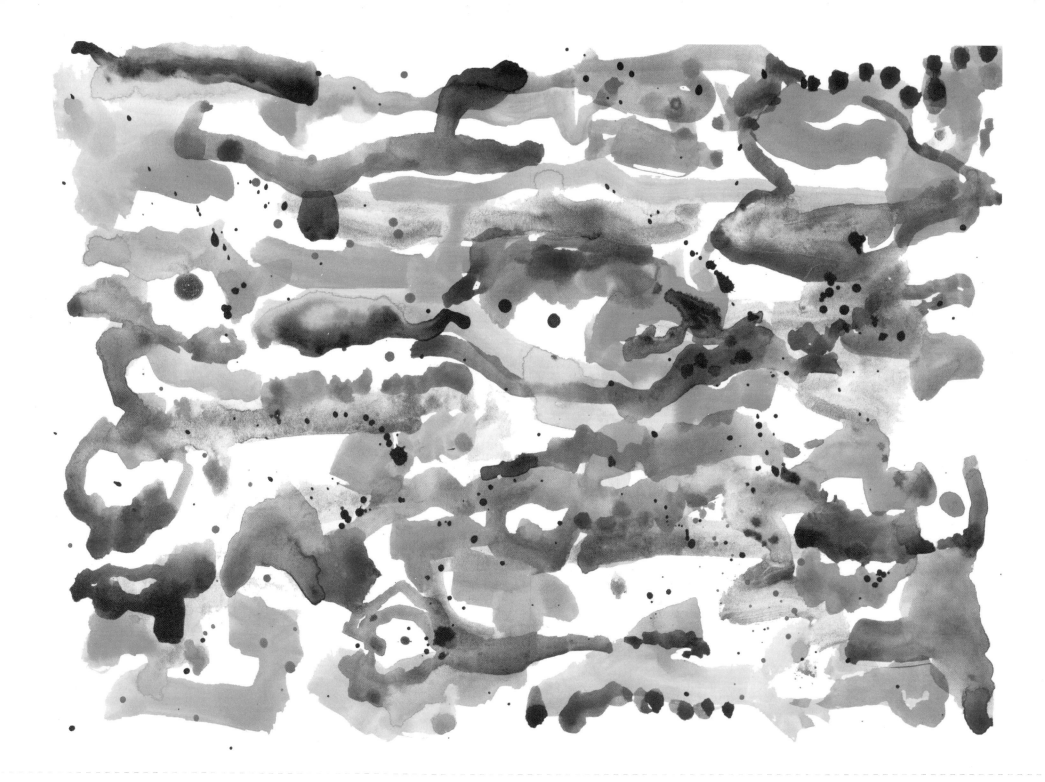

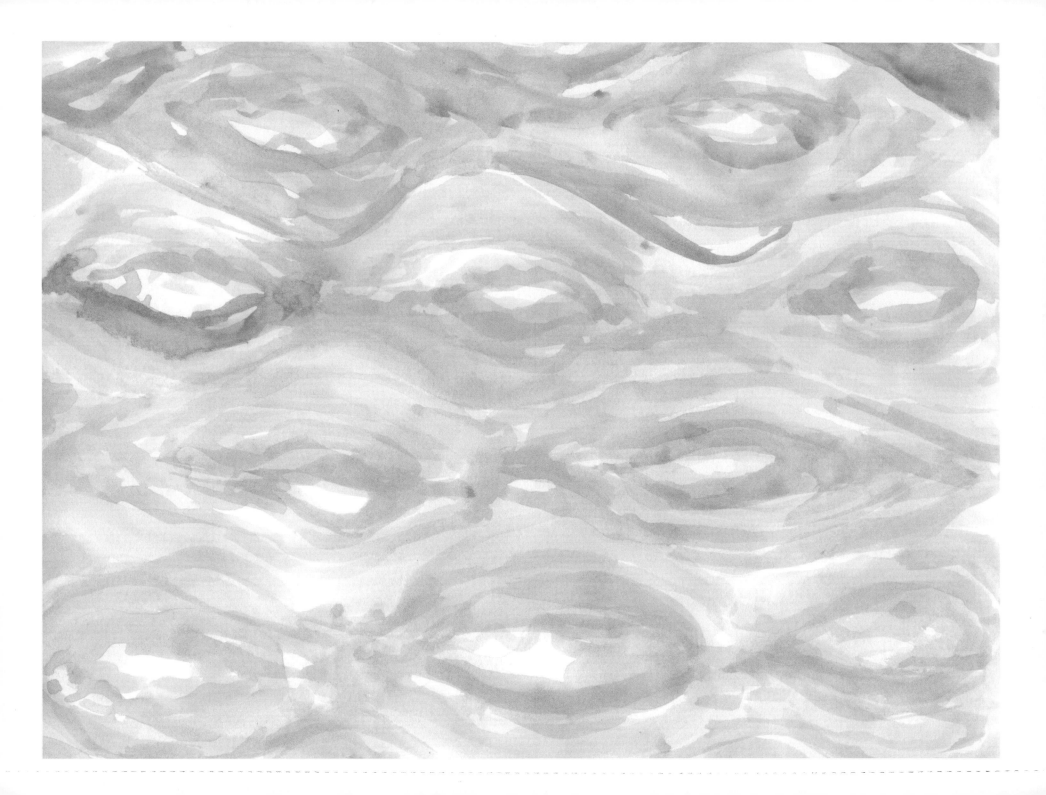

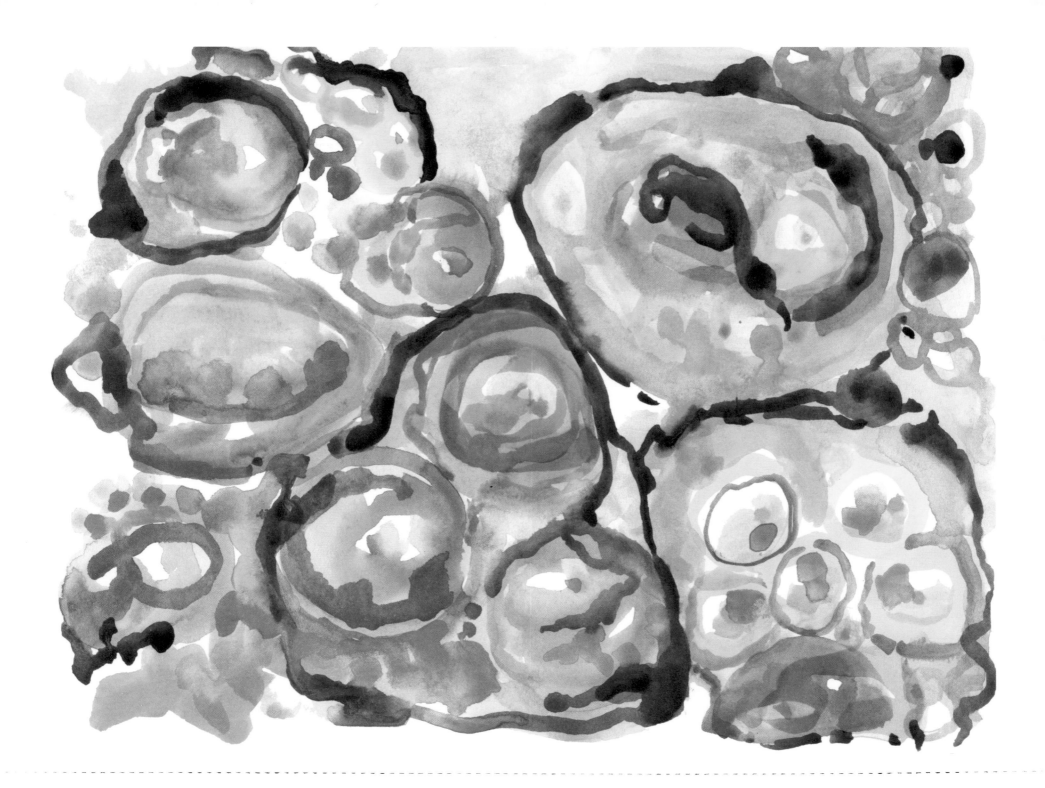

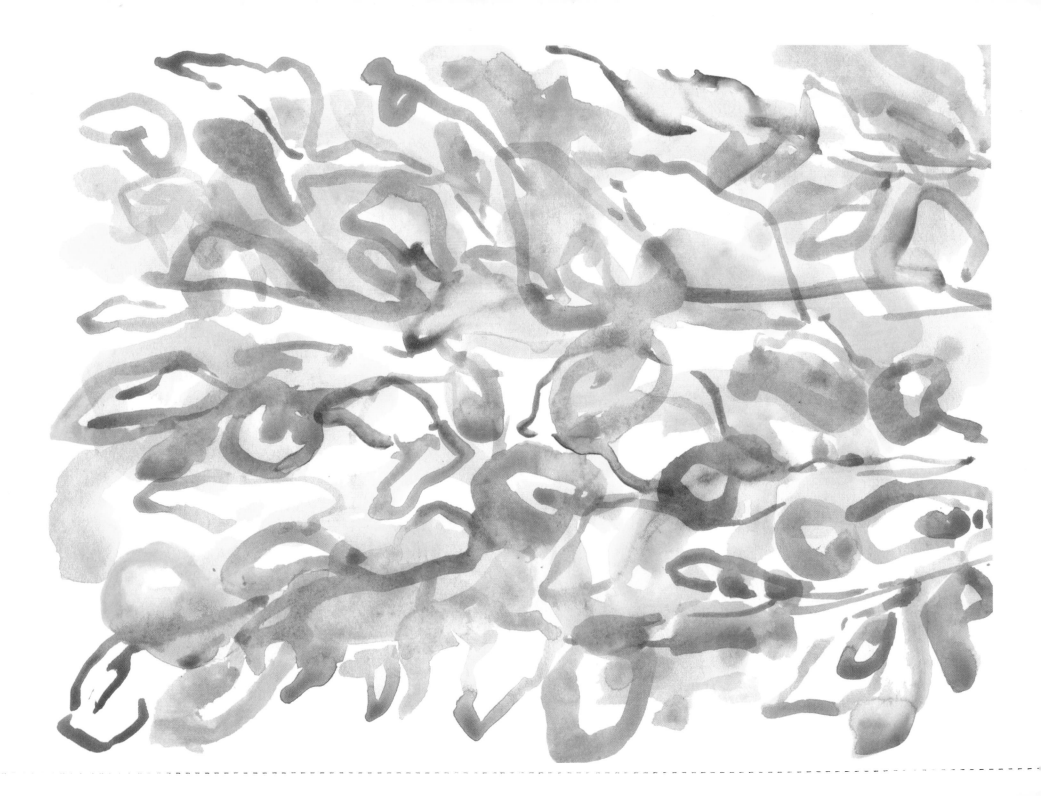

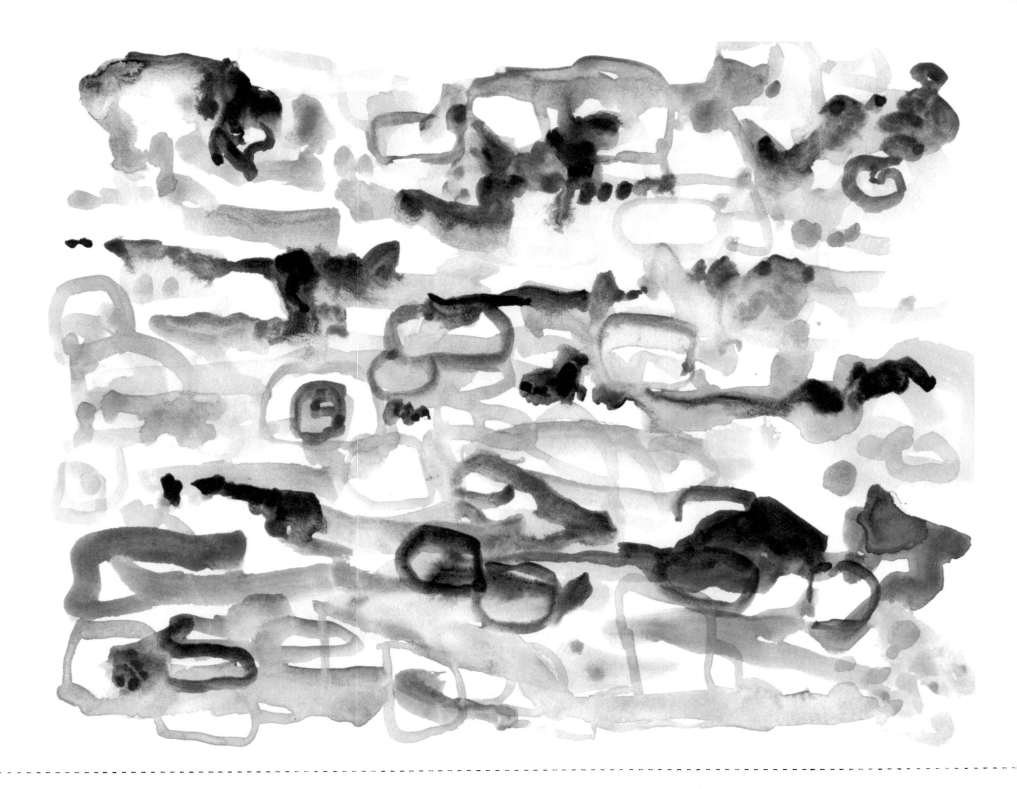

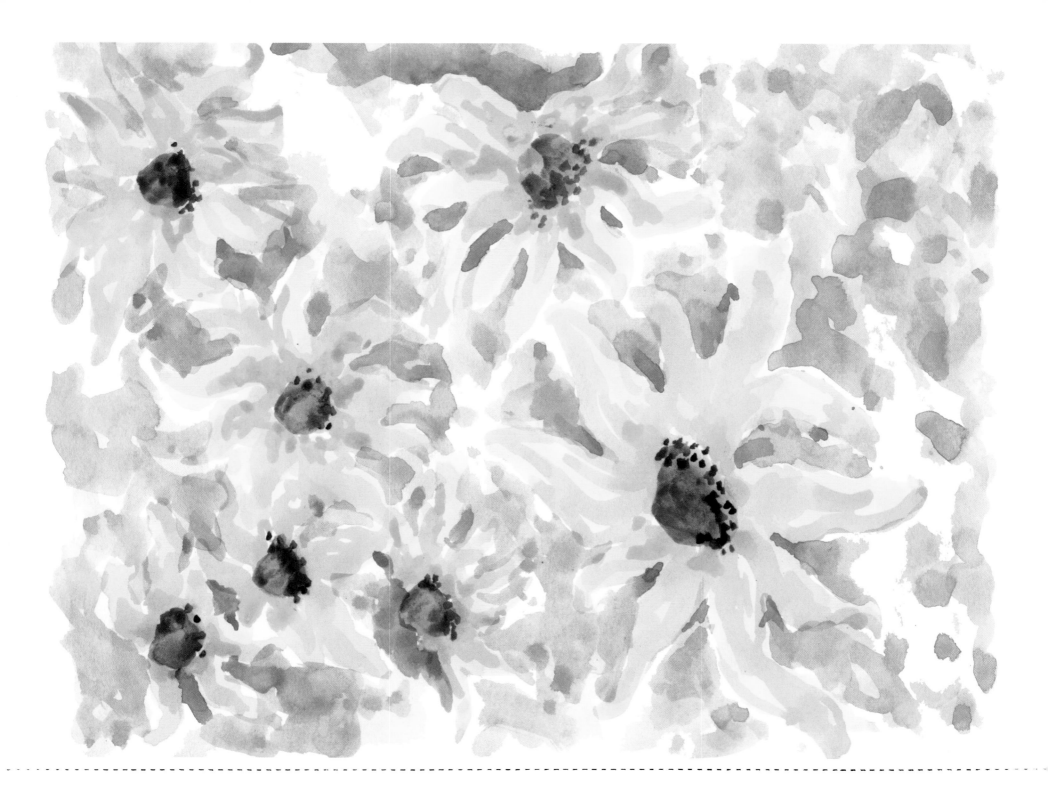

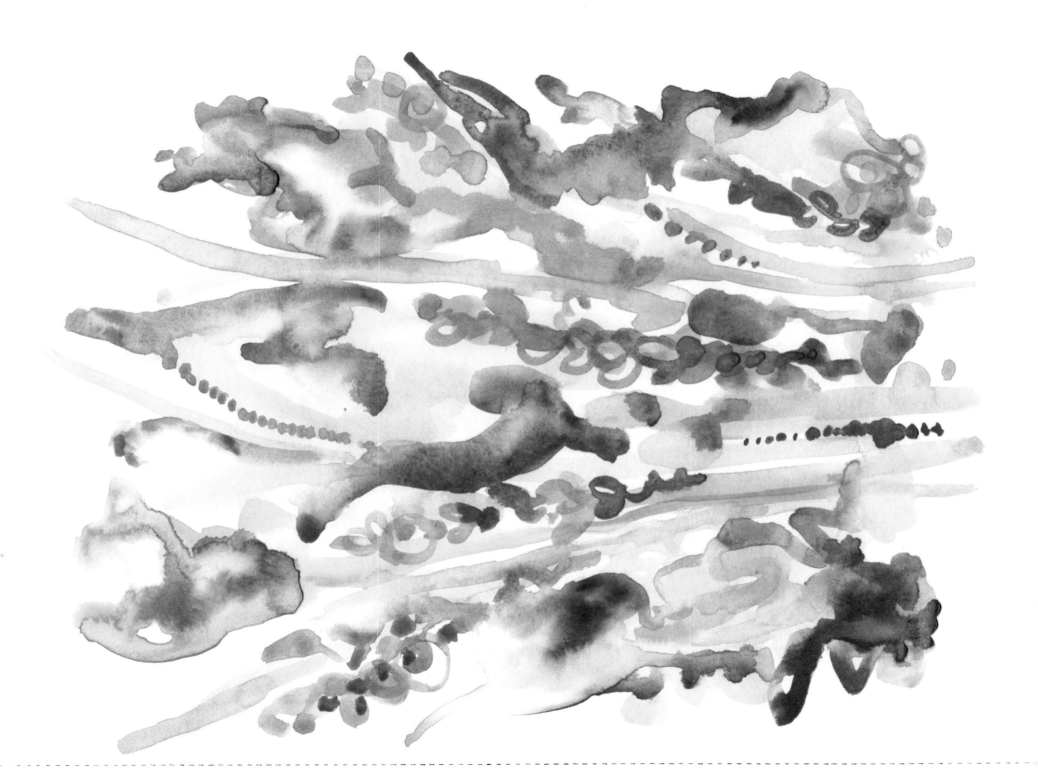

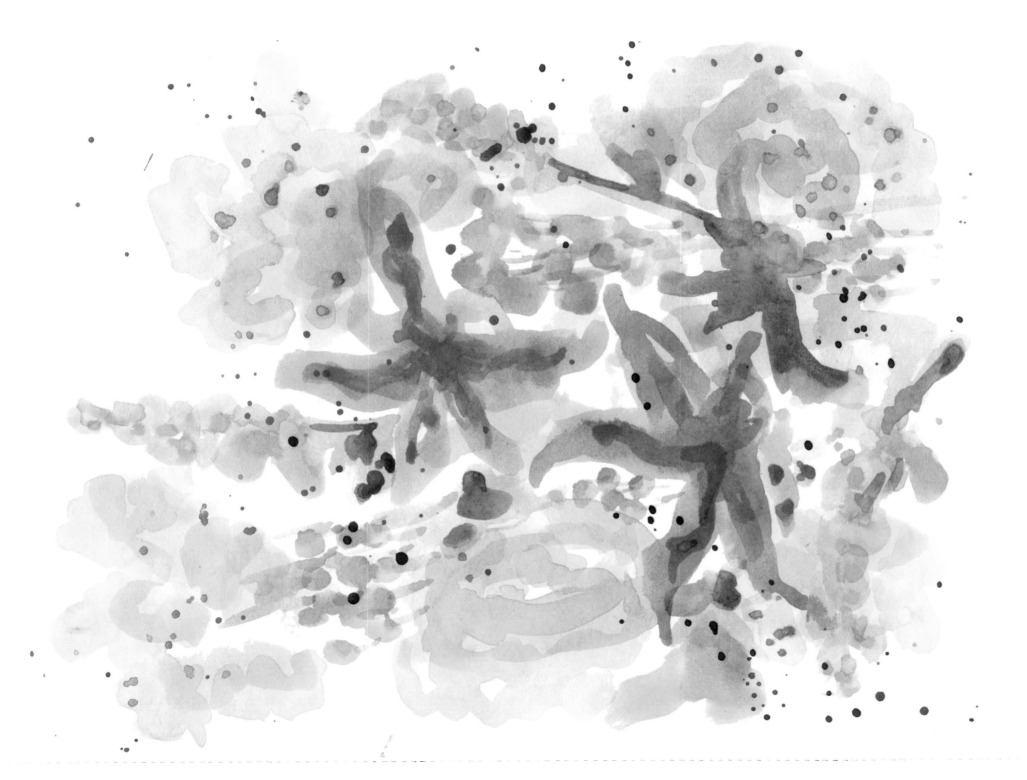

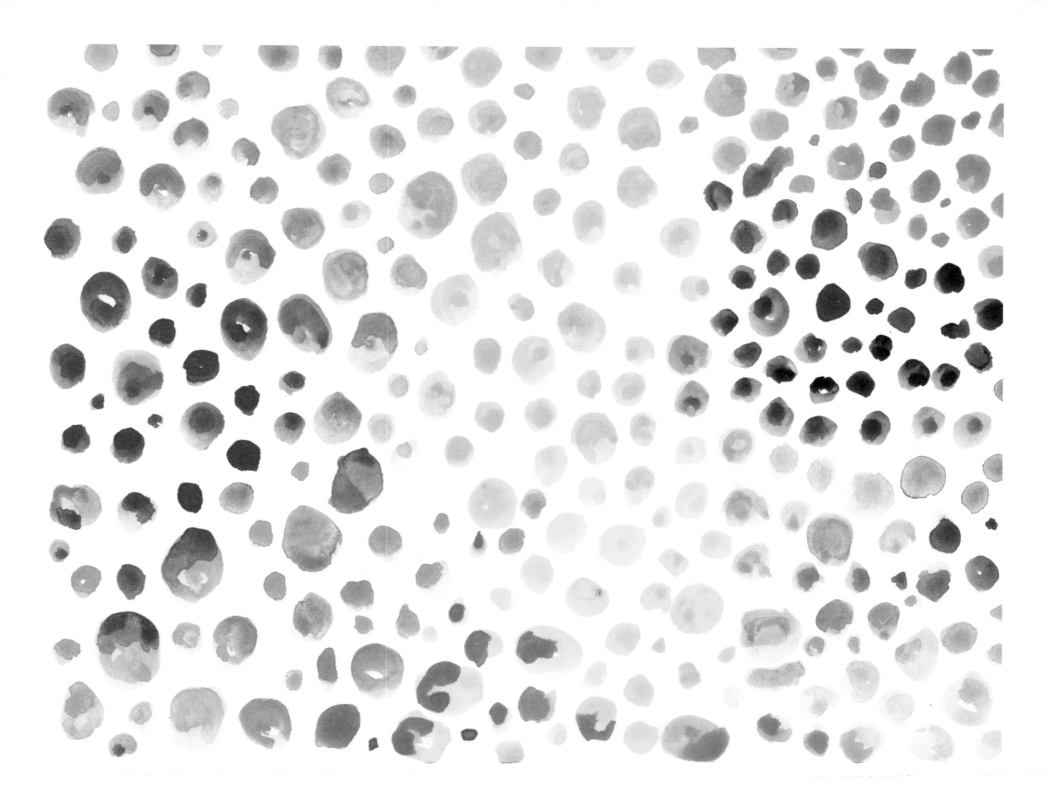

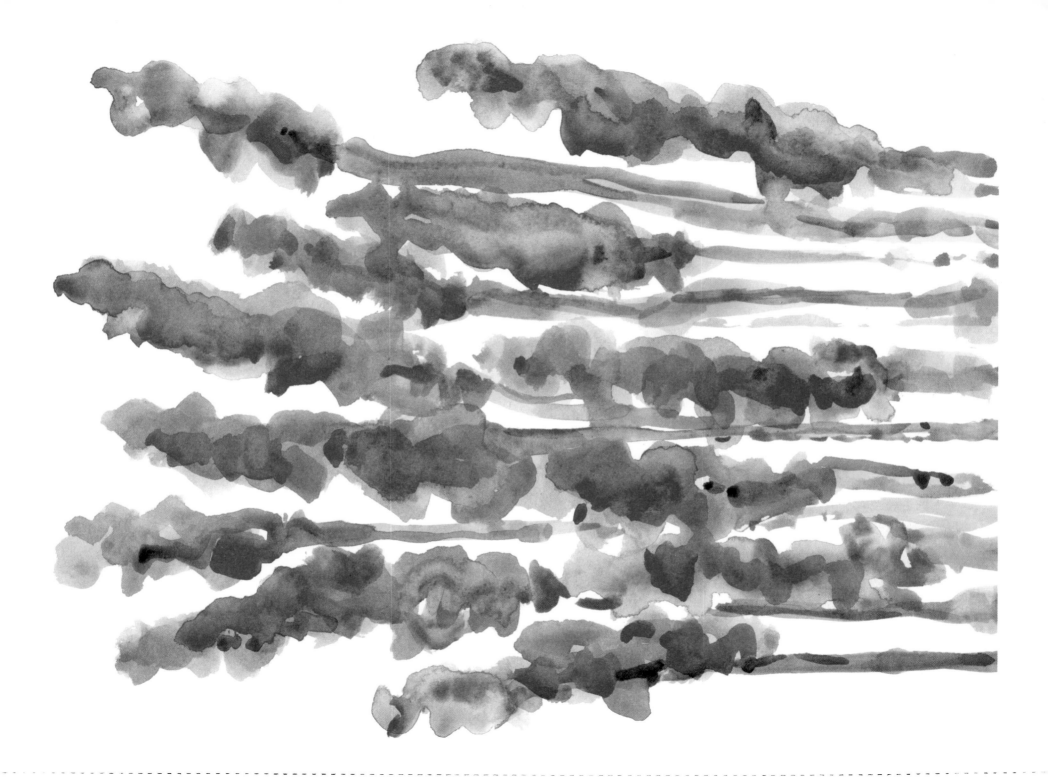

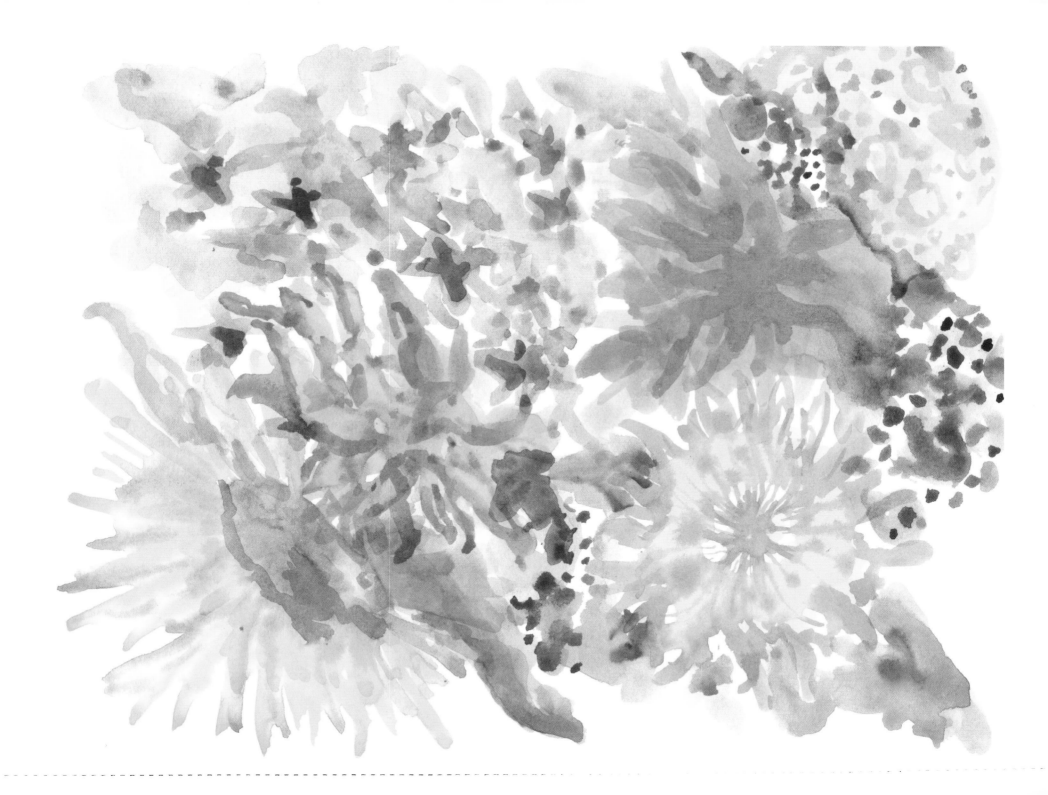

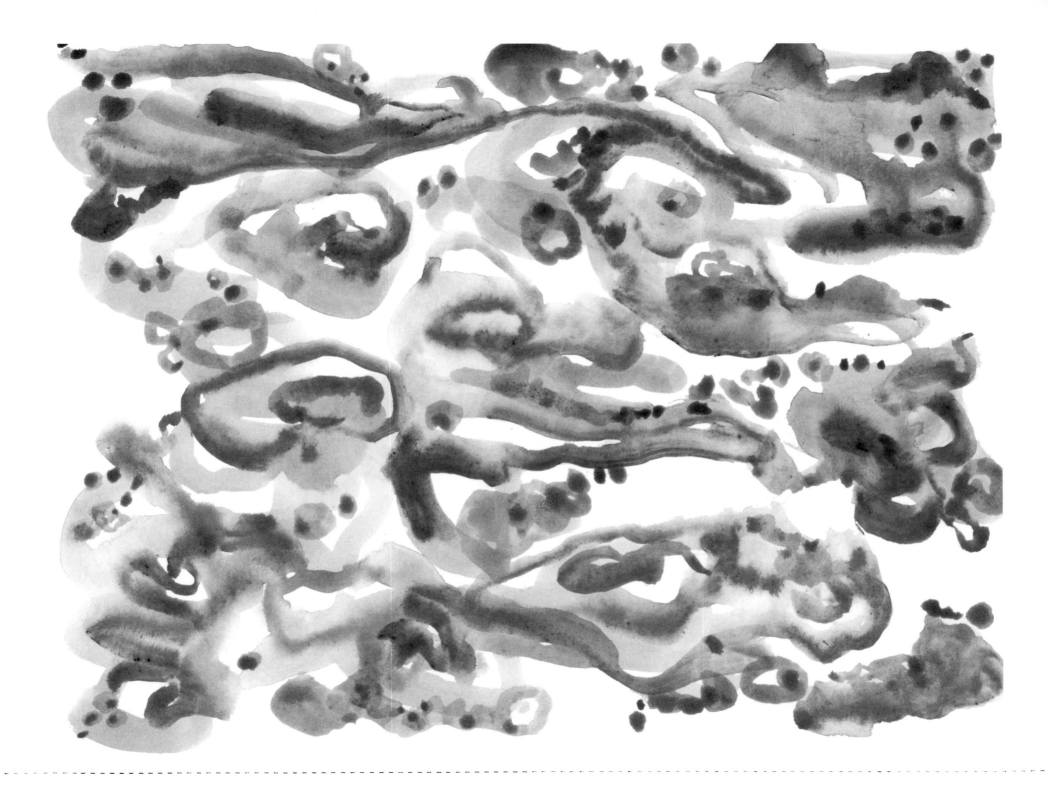

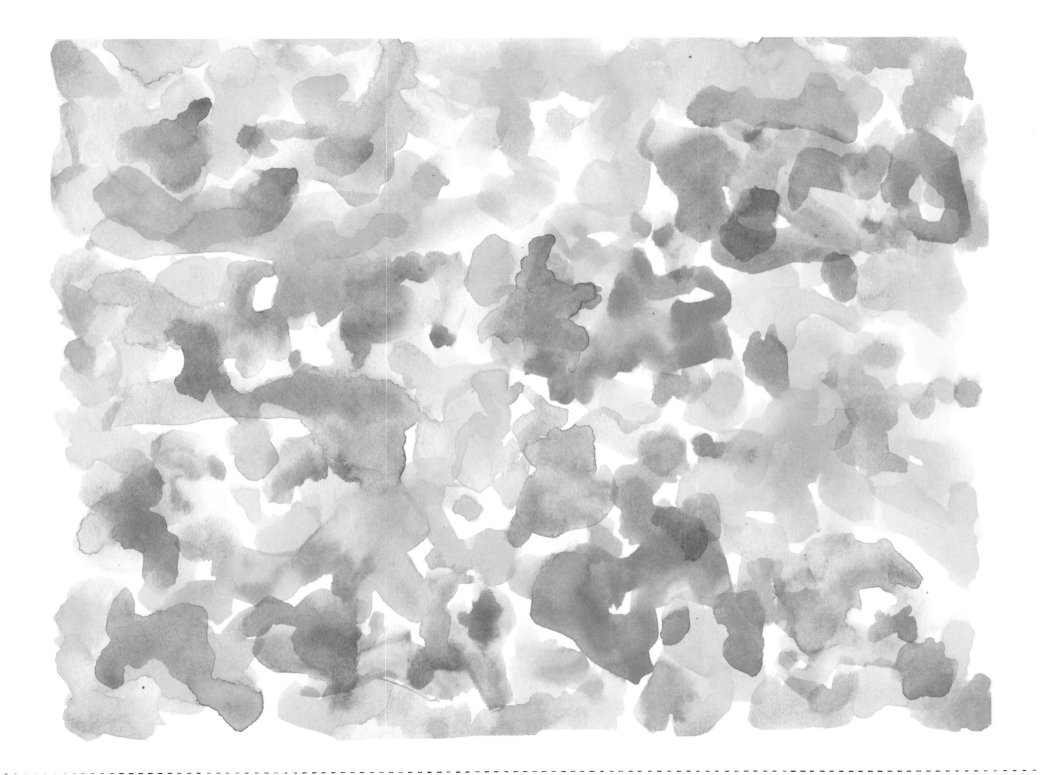

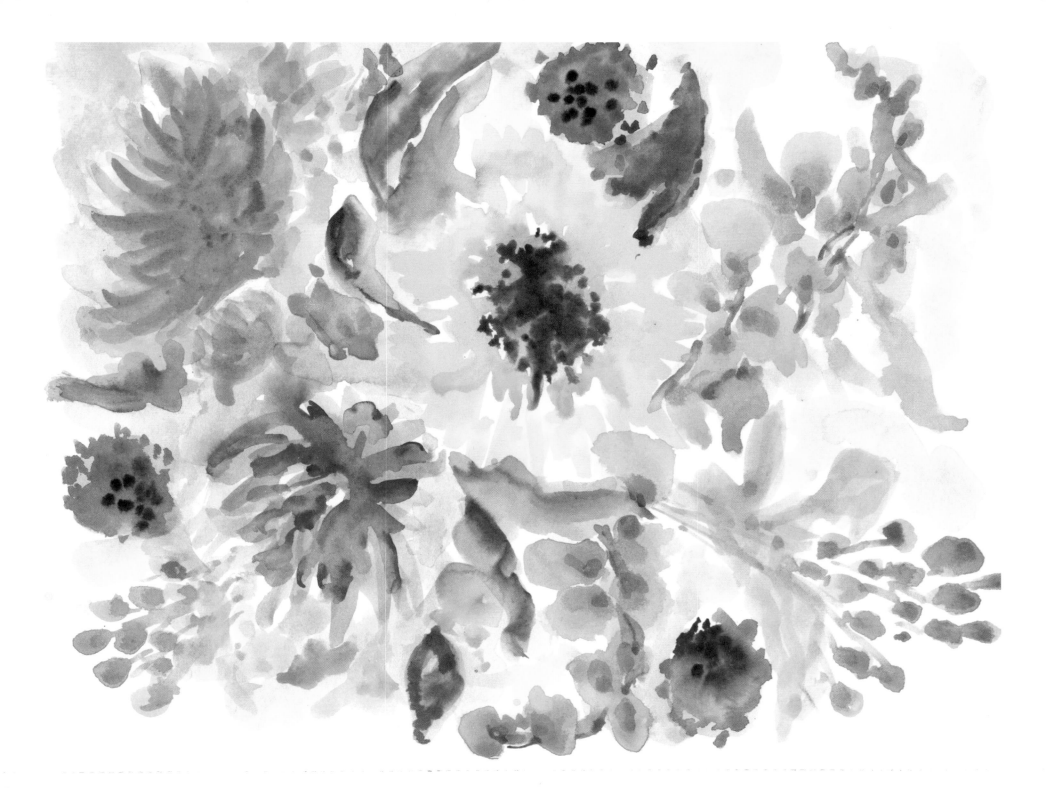

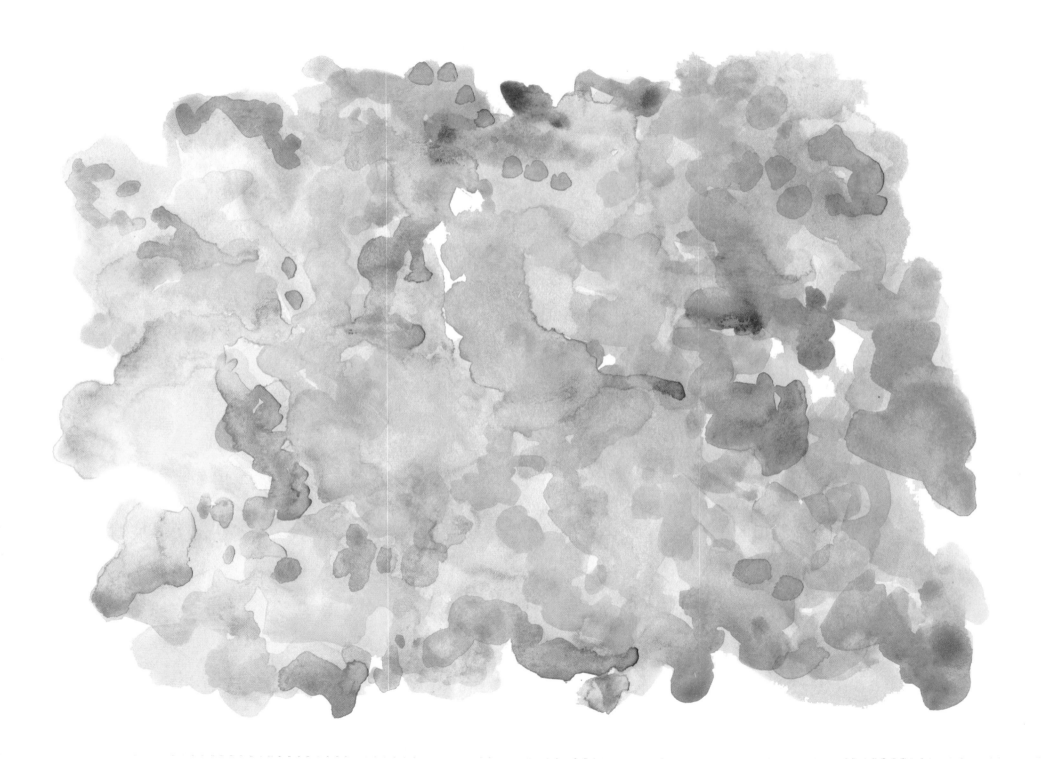

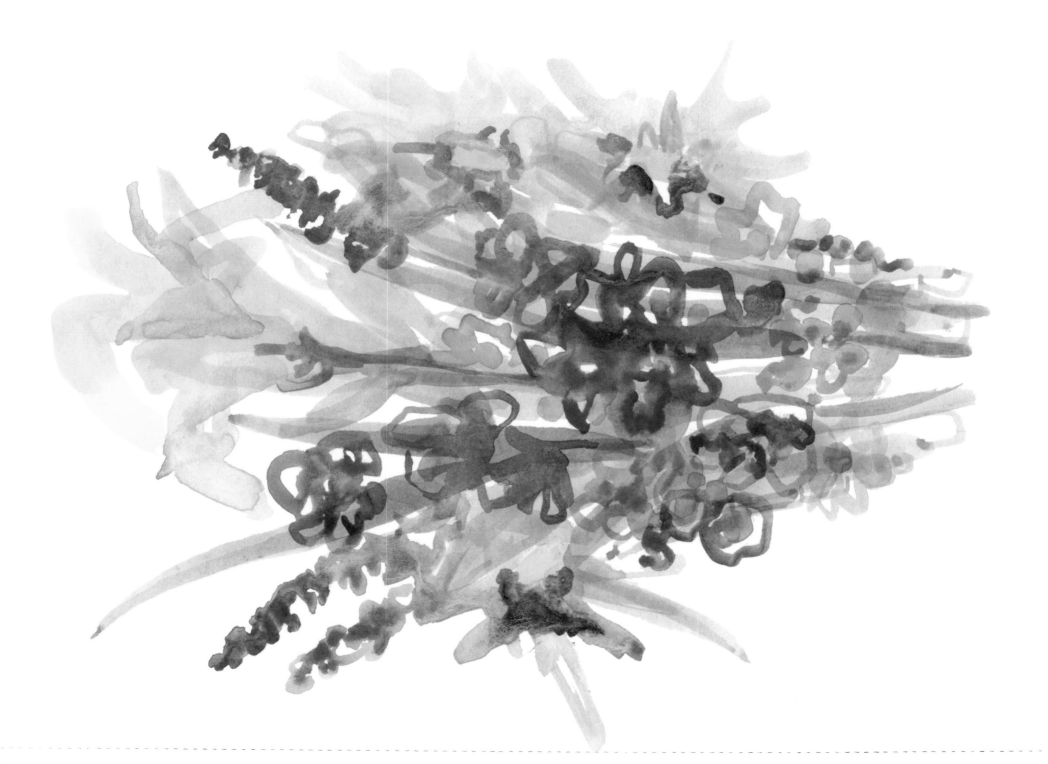

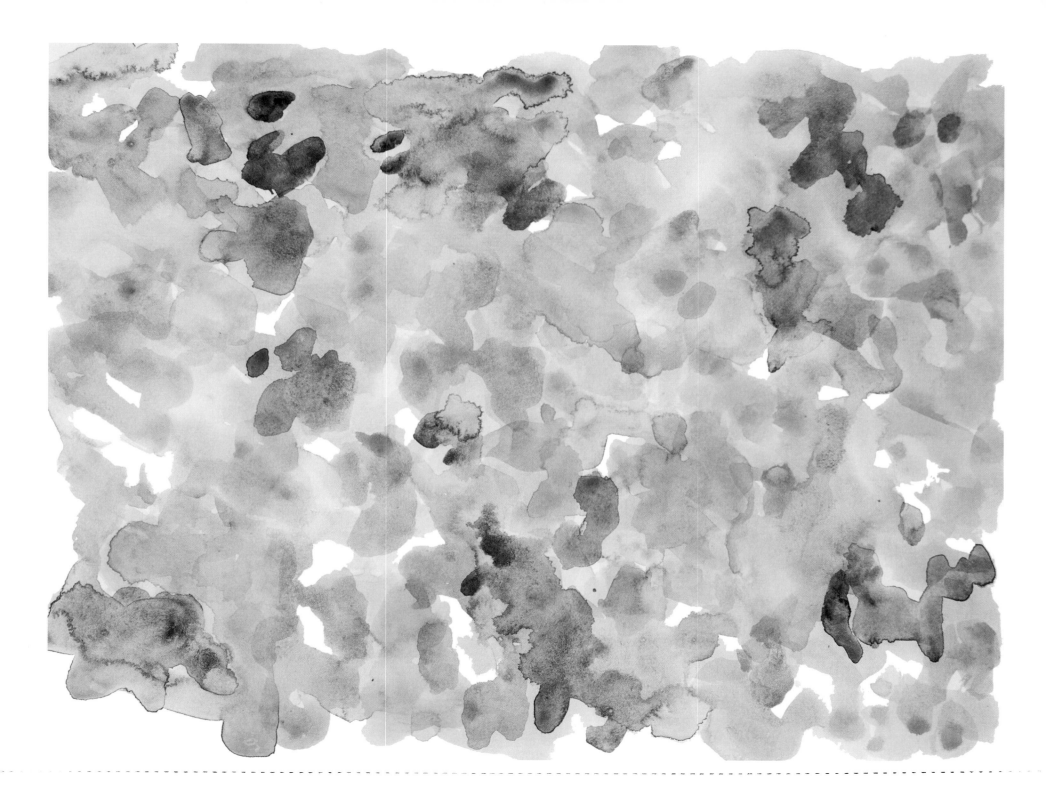

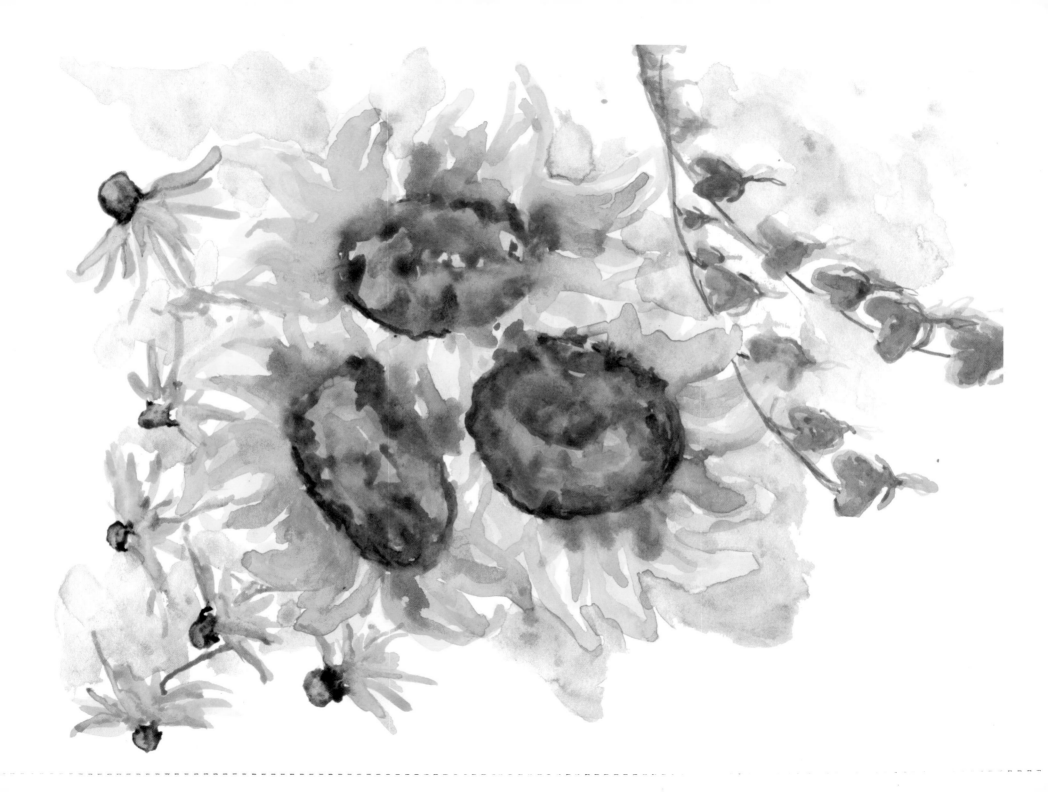

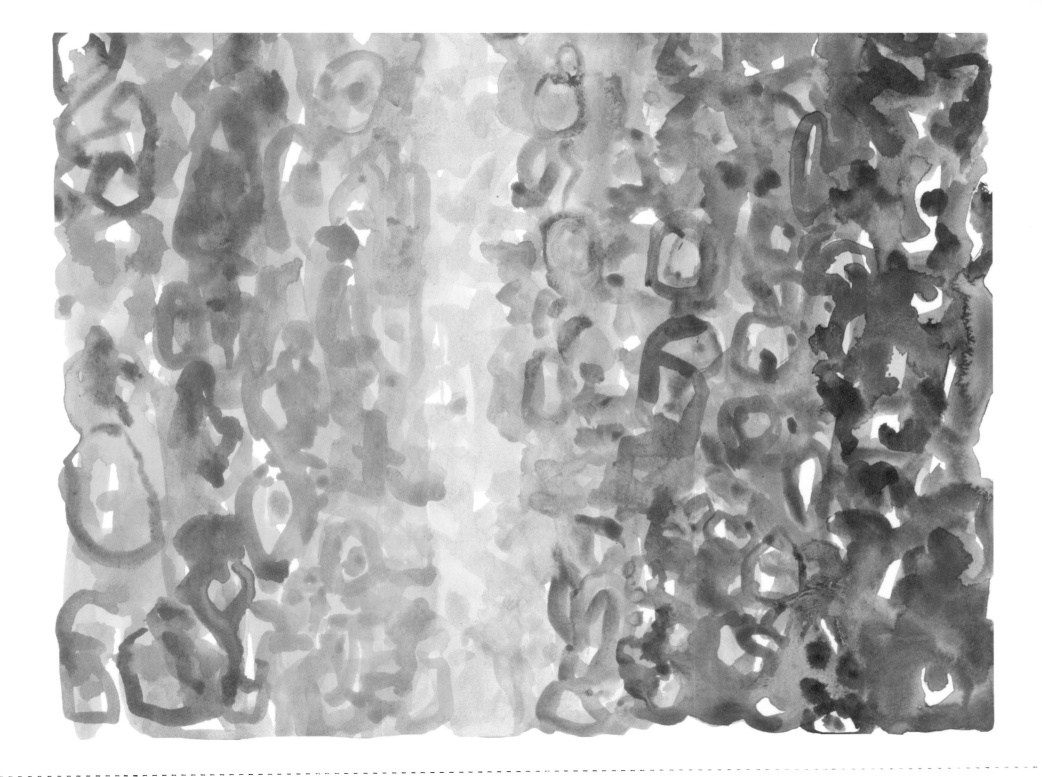

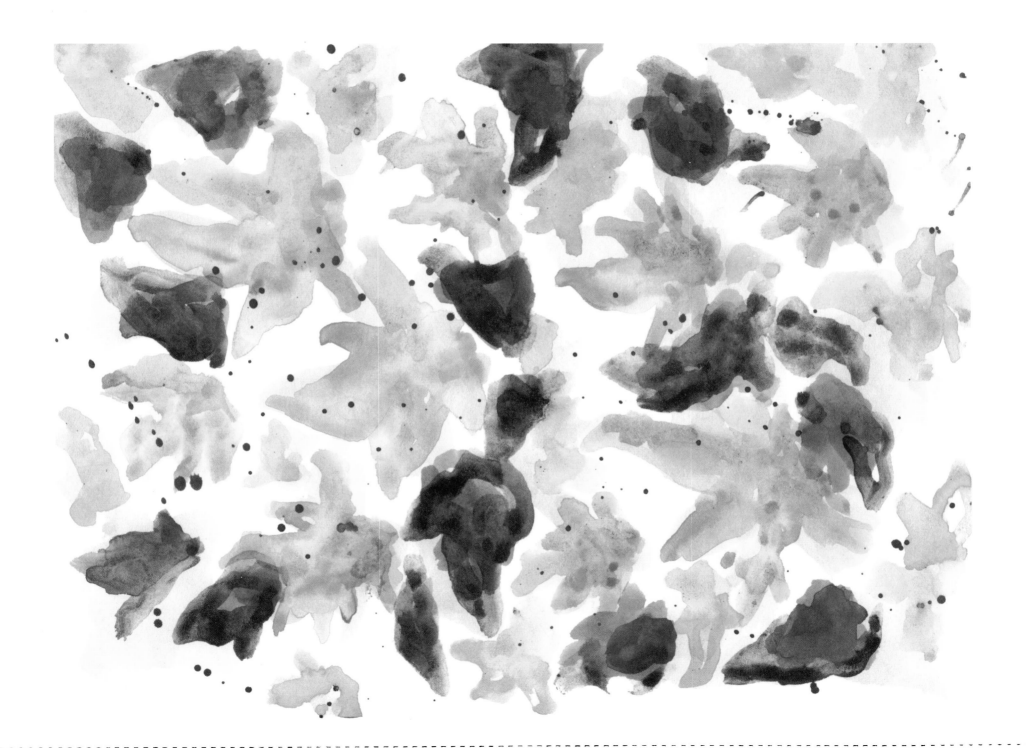

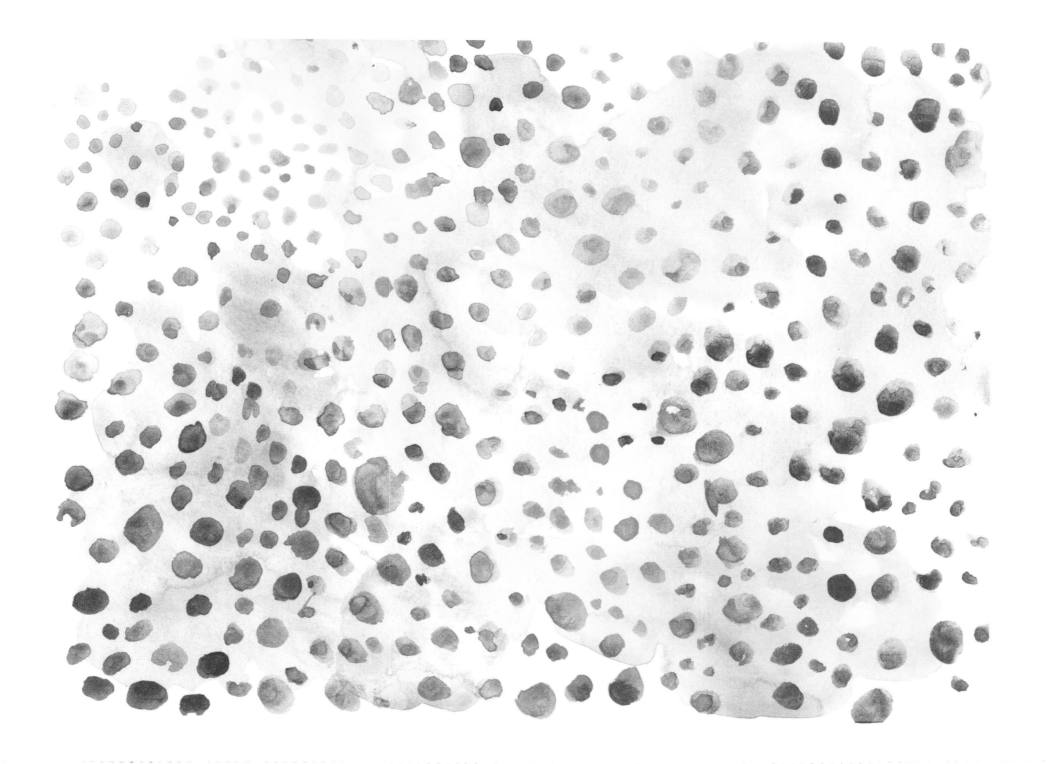

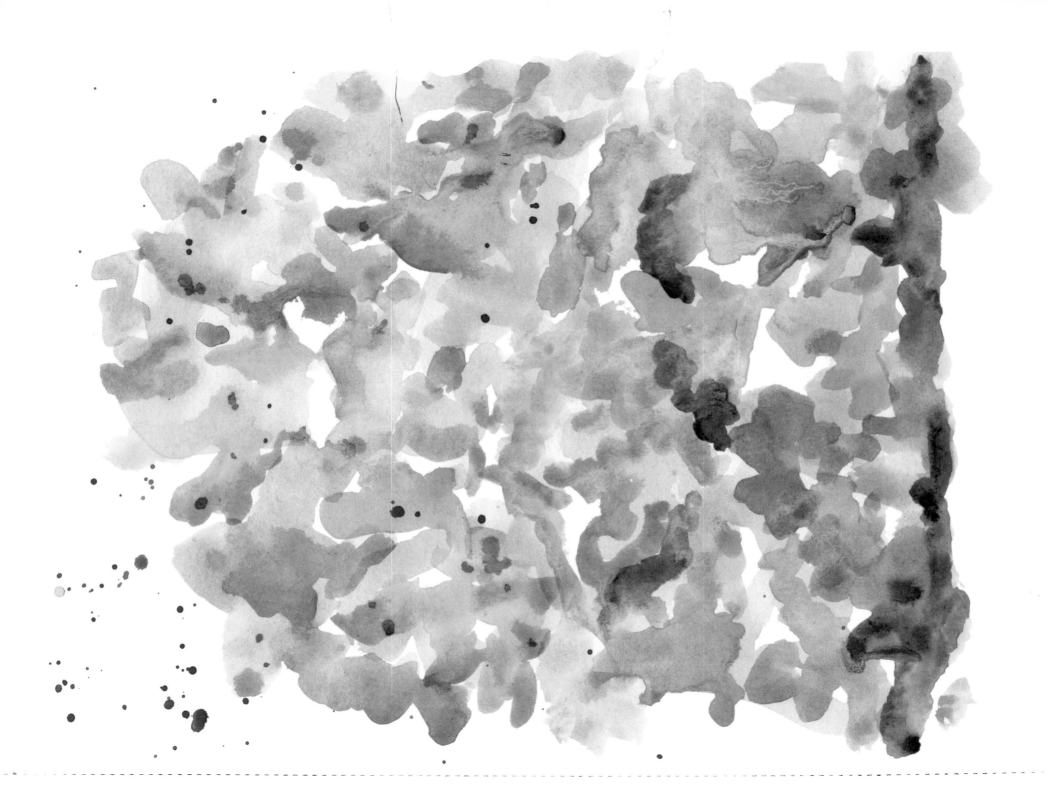

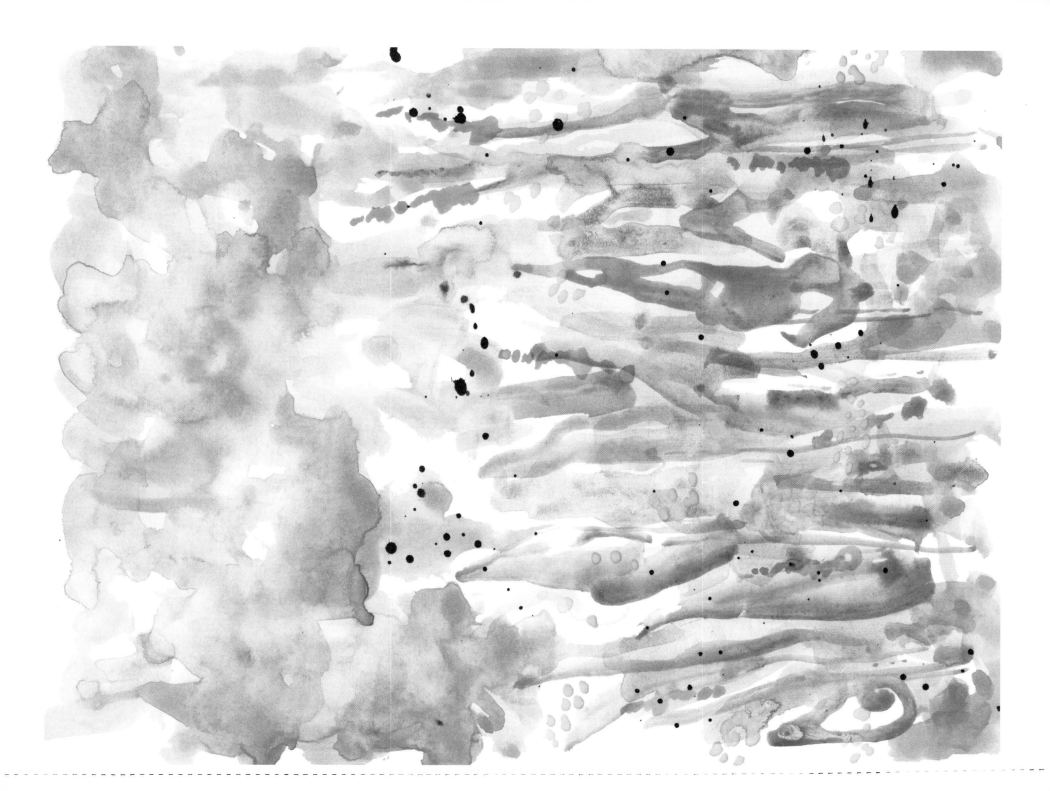

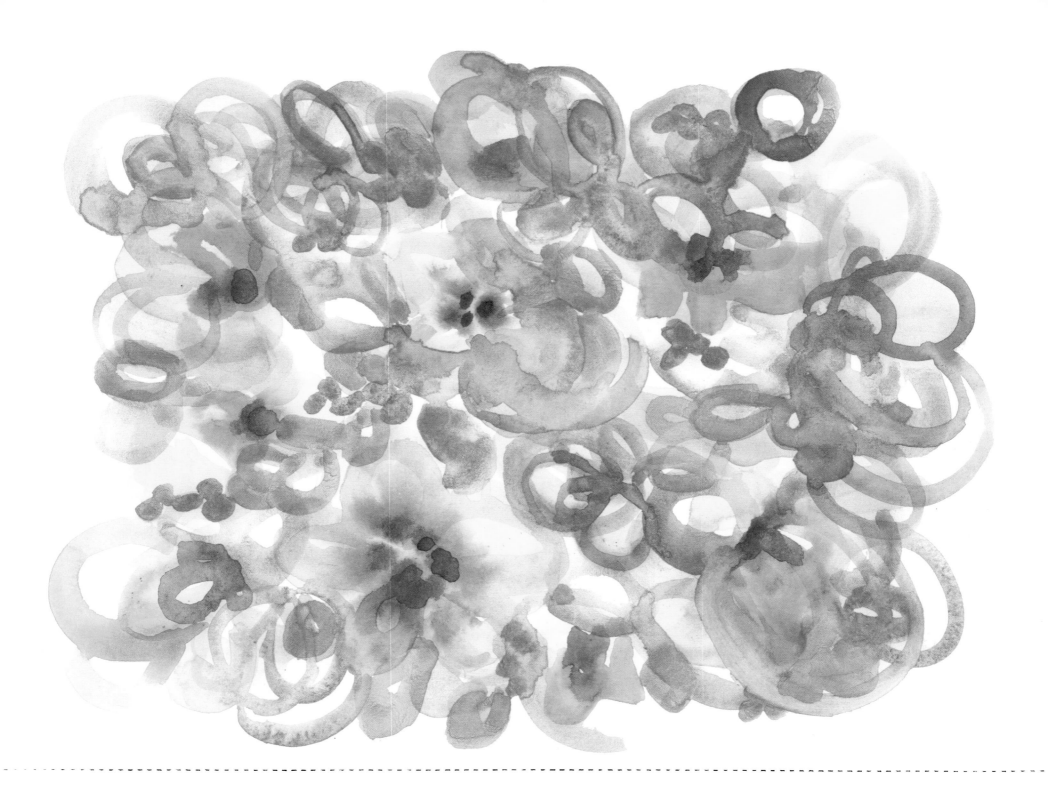

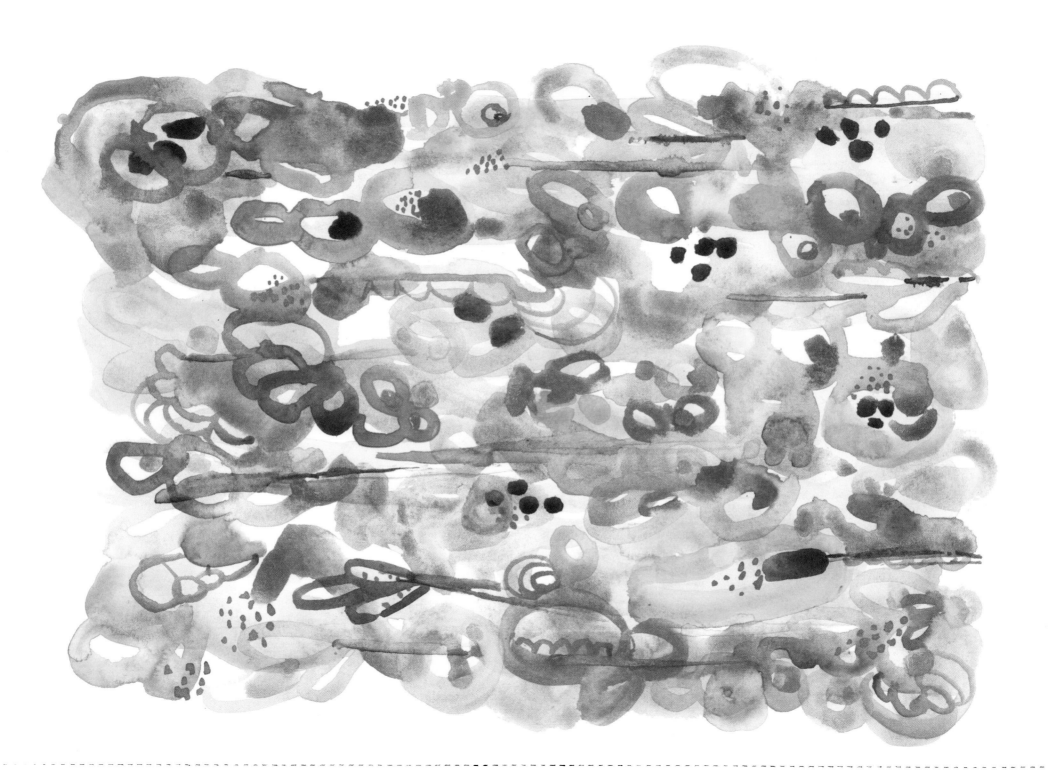

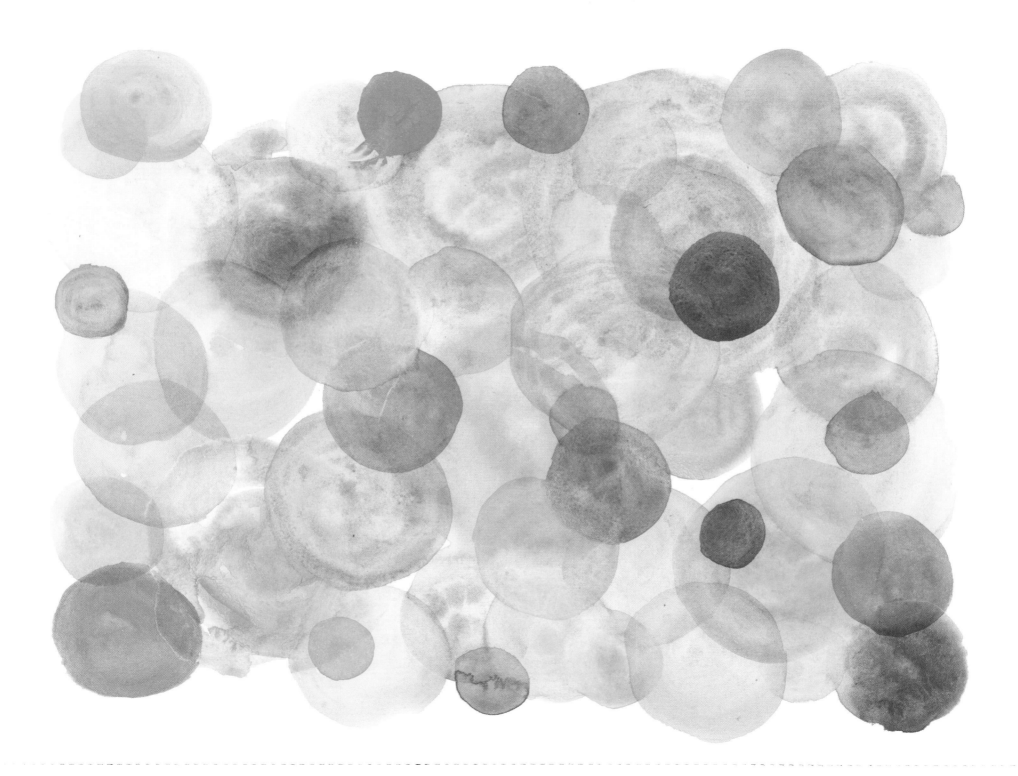

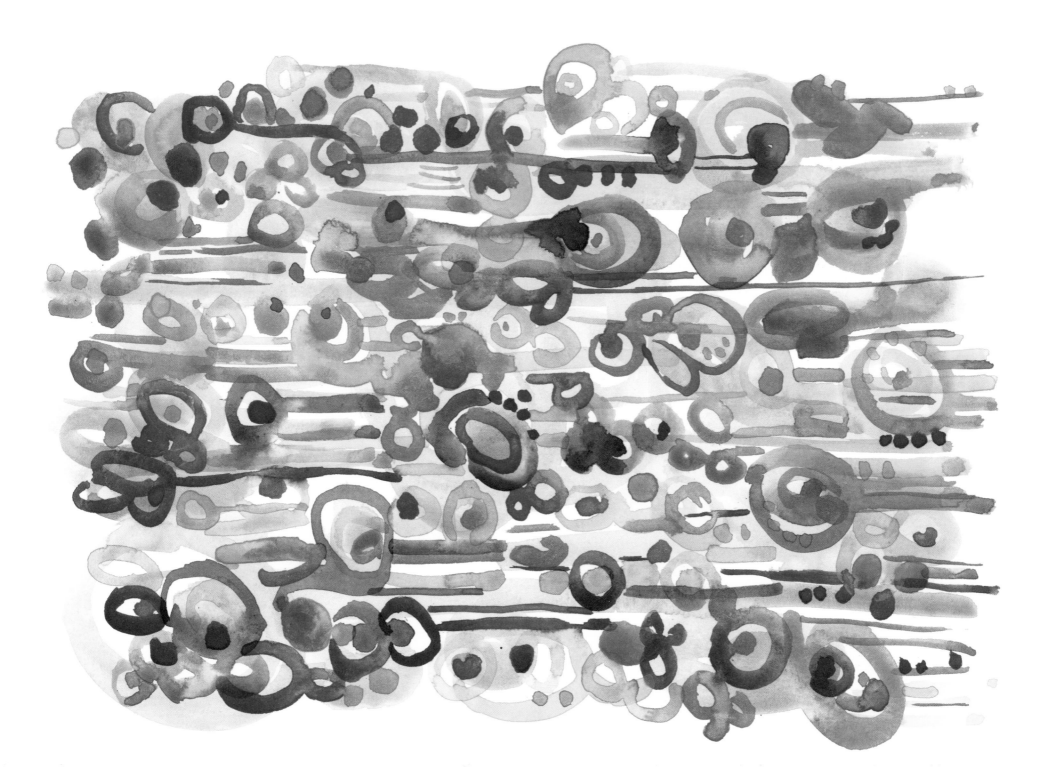

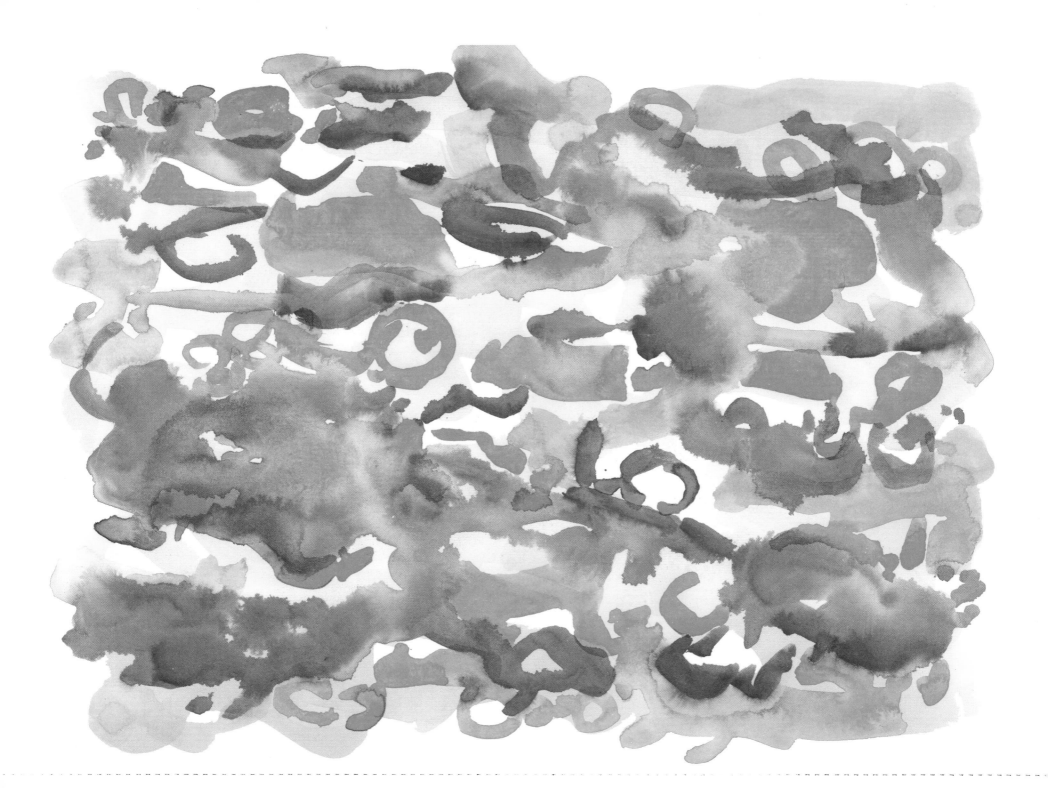

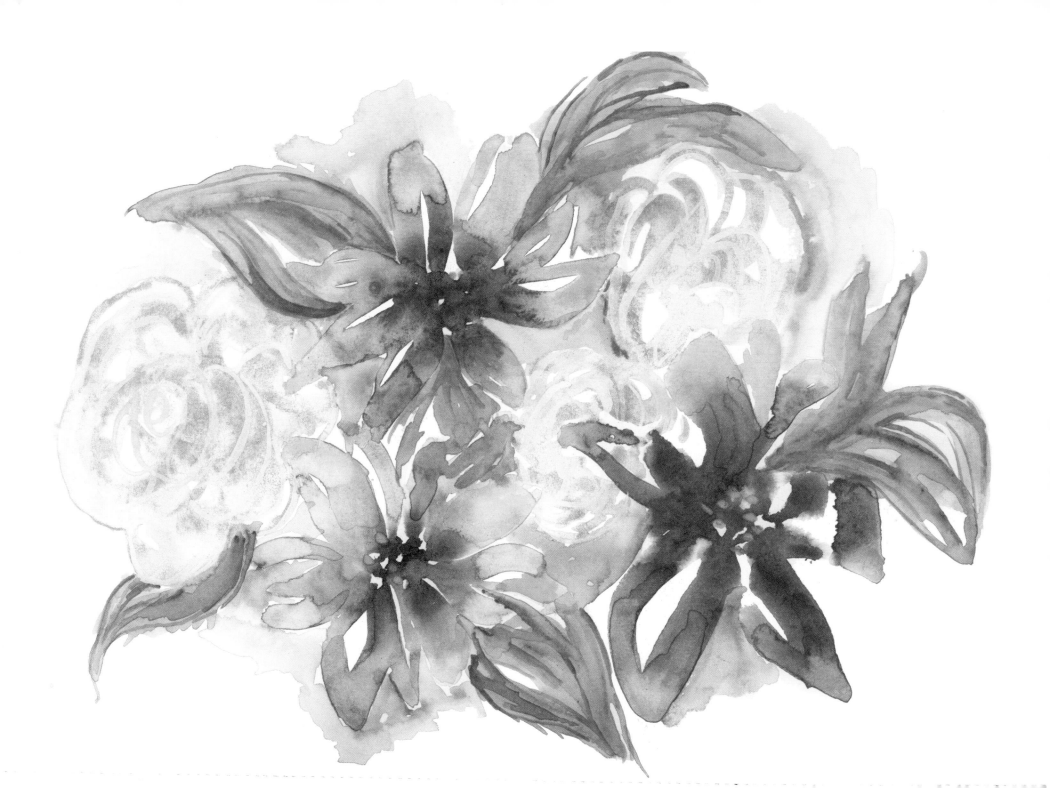

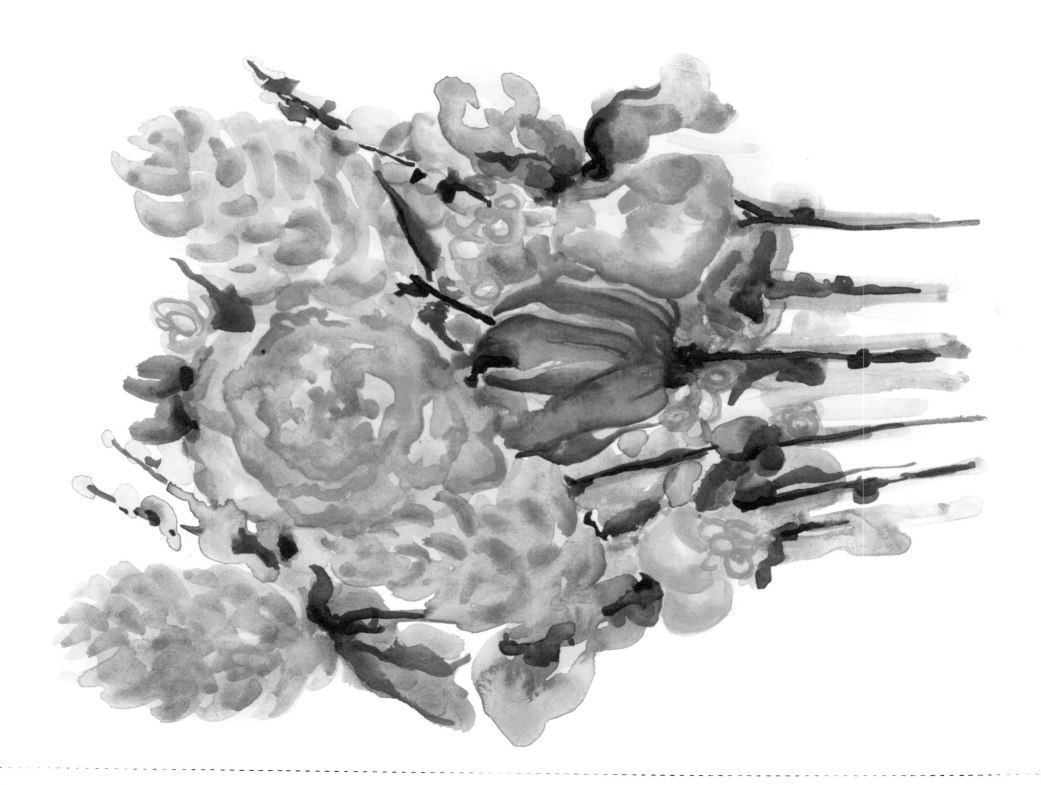

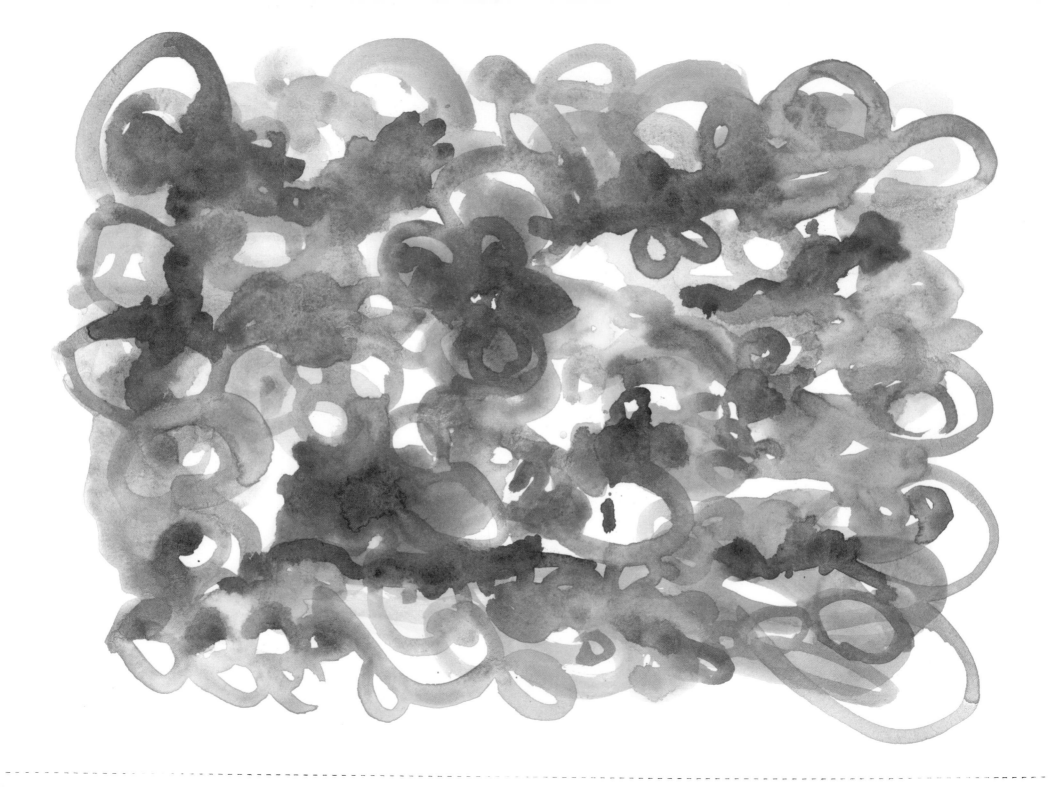

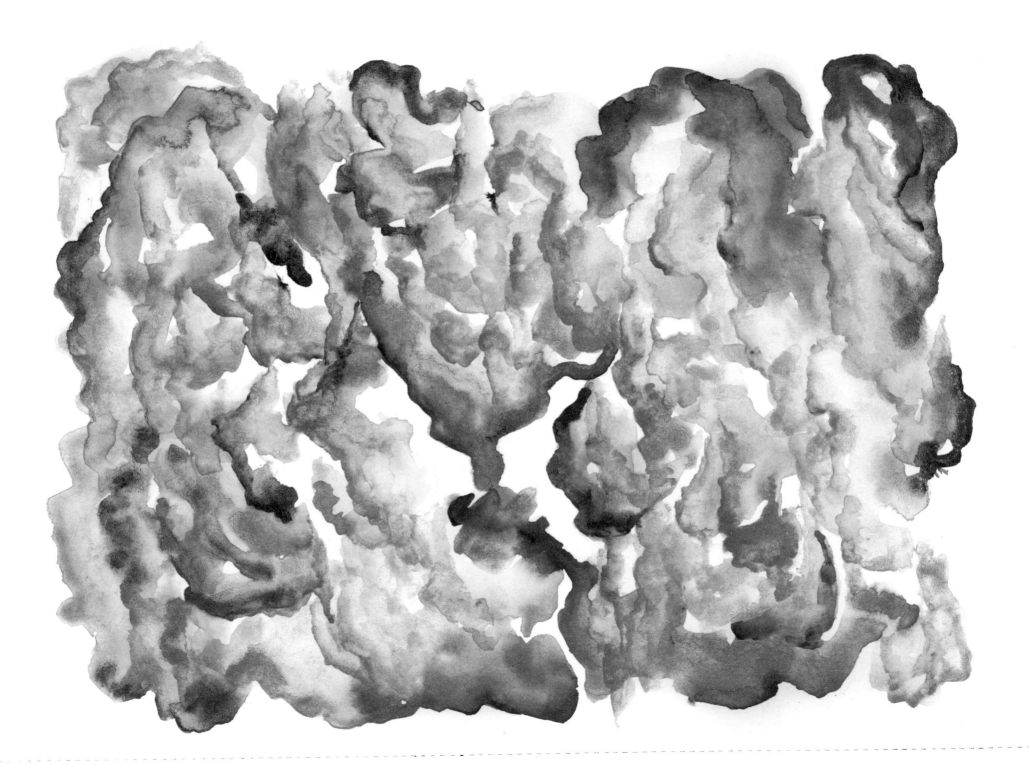